Color Your Own
Book of
Kells

Marty Noble

DOVER PUBLICATIONS, INC.
Mineola, New York

Bibliographical Note

Color Your Own Book of Kells is a new work, first published by Dover Publications, Inc., in 2001.

DOVER *Pictorial Archive* SERIES

International Standard Book Number: 0-486-41865-0

Manufactured in the United States of America
Dover Publications, Inc., 31 East 2nd Street, Mineola, N.Y. 11501

NOTE

One of the most beautiful books of the early Middle Ages, the Book of Kells is an illuminated copy of the four gospels of the New Testament in Latin. This illuminated manuscript was probably completed sometime around A.D. 800 in Ireland. The wealth of decoration on nearly every page makes this manuscript unique. The elaborate and colorful ornamentation, derived from numerous art traditions, includes symbolic abstractions of both animals and people, traditional Celtic spirals and interlaces, and highly stylized designs. Adapted by artist Marty Noble, the twenty-eight illustrations in this book capture the intricacy and free-flowing beauty that is characteristic of Celtic art.

Five color plates, appearing on the front and back covers, depict striking reproductions of motifs from the Book of Kells. If you wish, you may follow the color scheme of these illustrations, or you can fill in the intricate outlines with patches of subtle or bright color to create your own works of art.

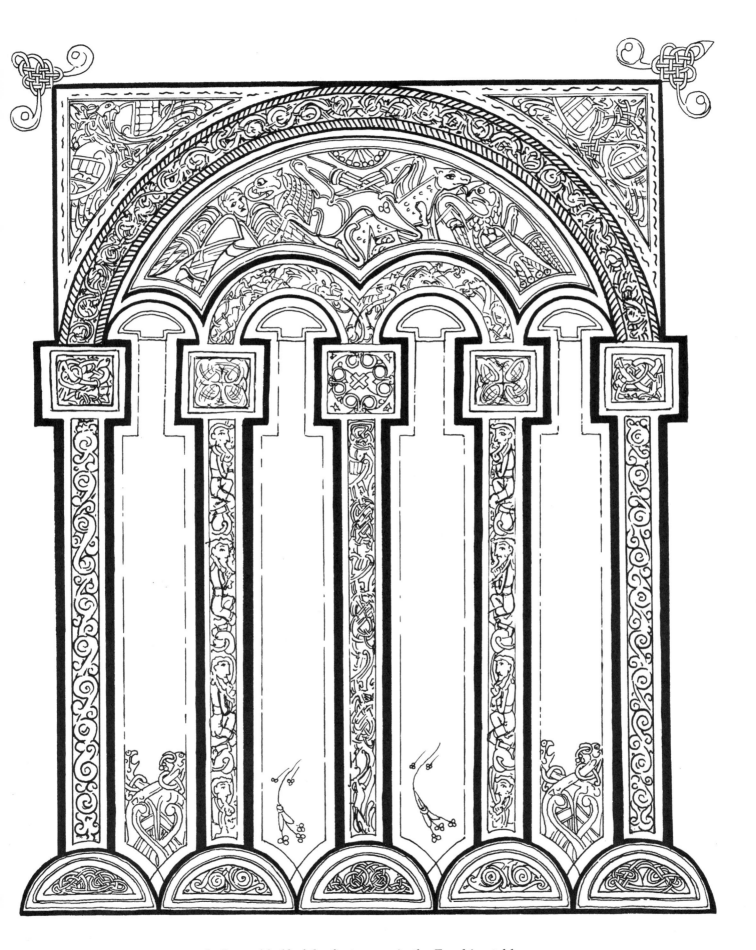

1. Second half of the first canon in the Eusebian tables.

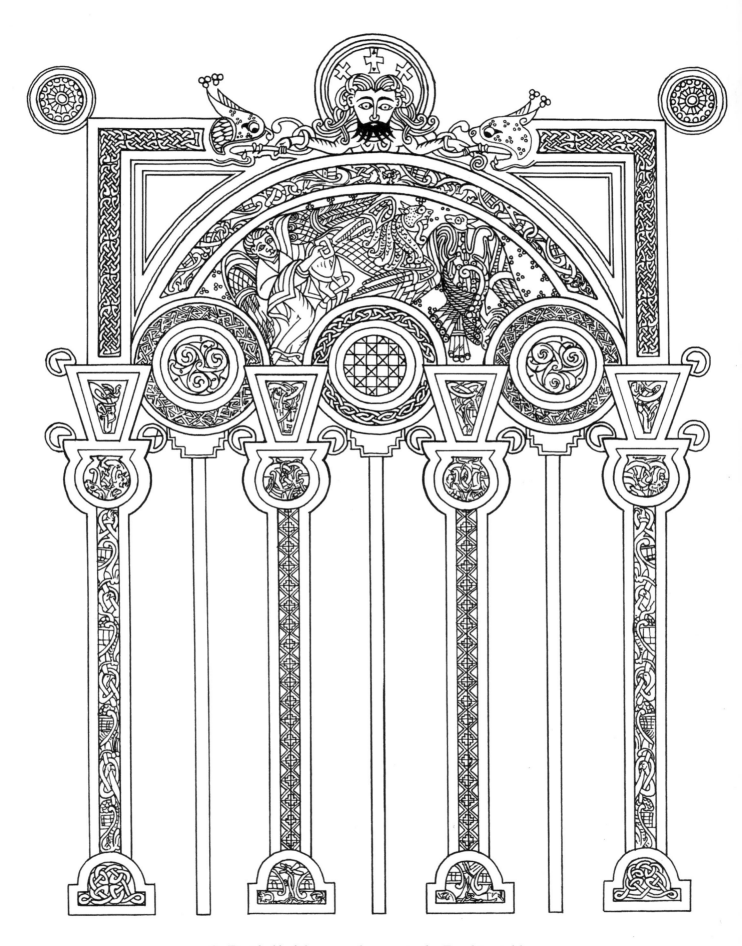

2. First half of the second canon in the Eusebian tables.

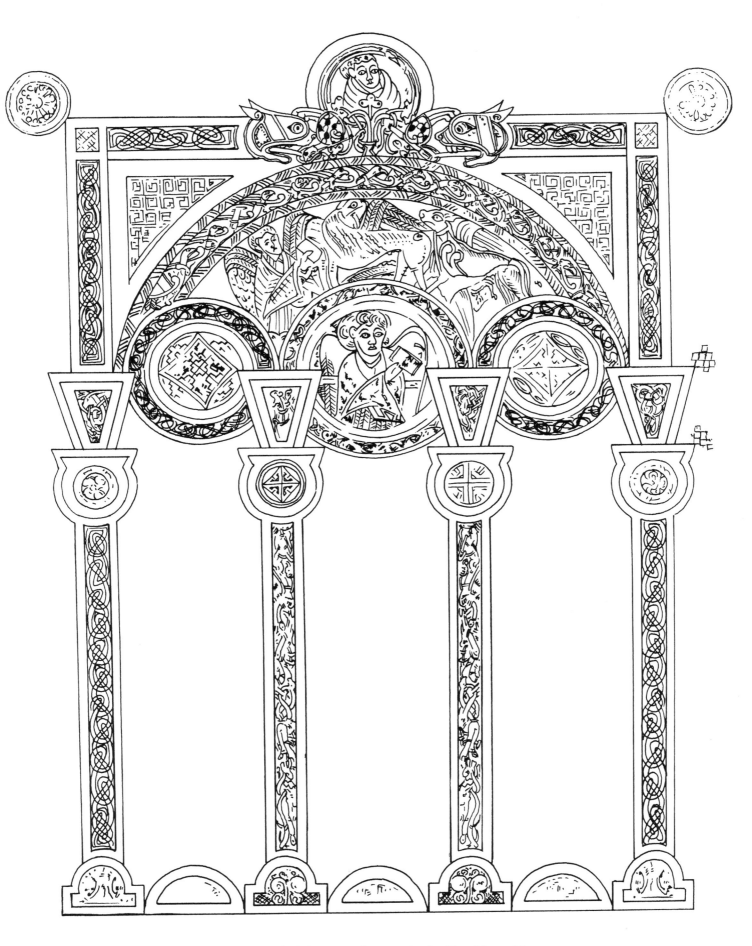

3. Second half of the second canon in the Eusebian tables.

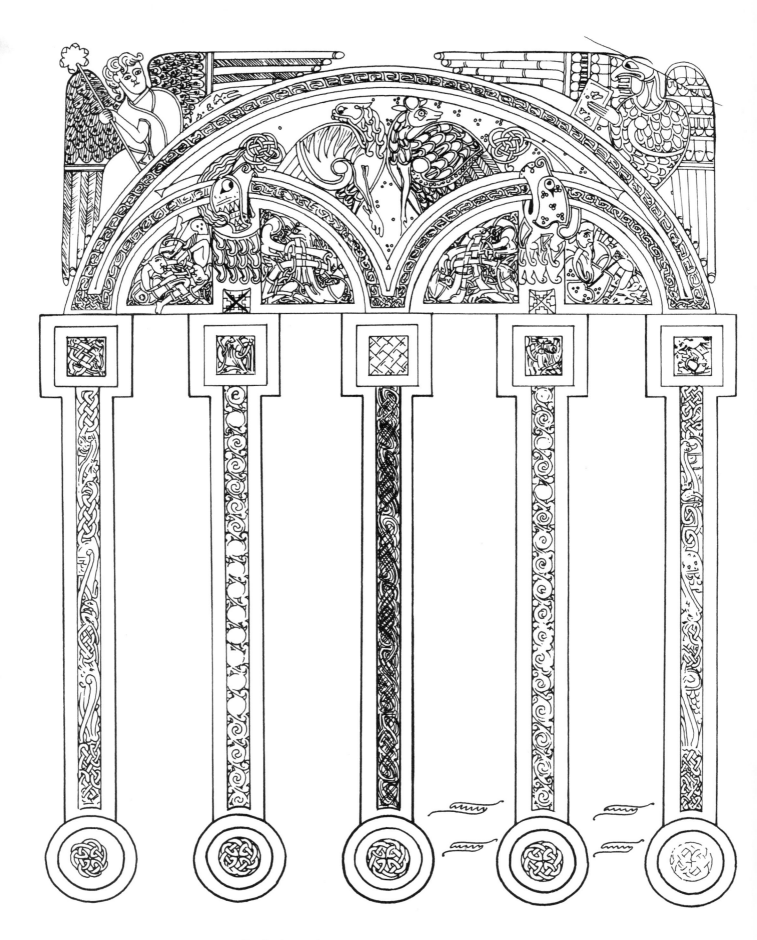

4. Sixth through eighth canons in the Eusebian tables.

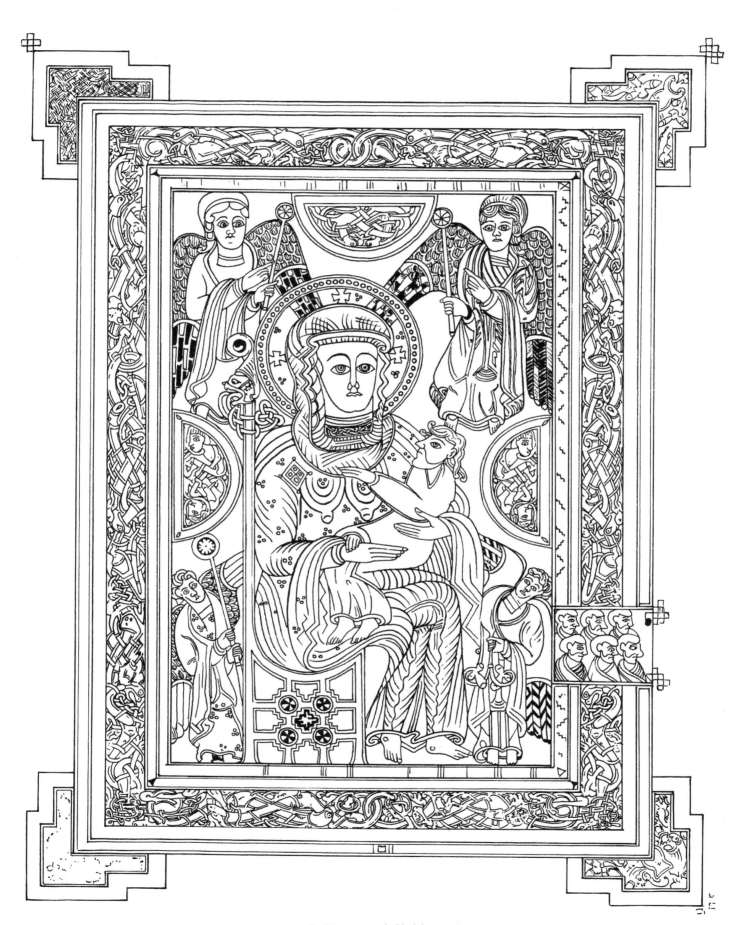

5. Virgin and Child.

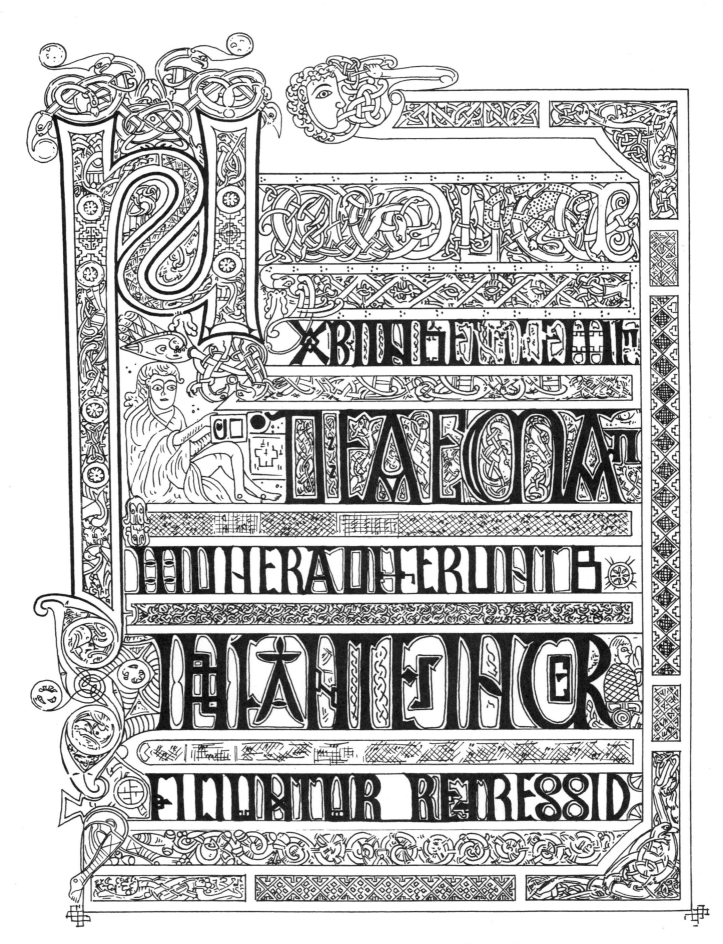

6. Beginning of the summary of the Gospel According to Matthew.

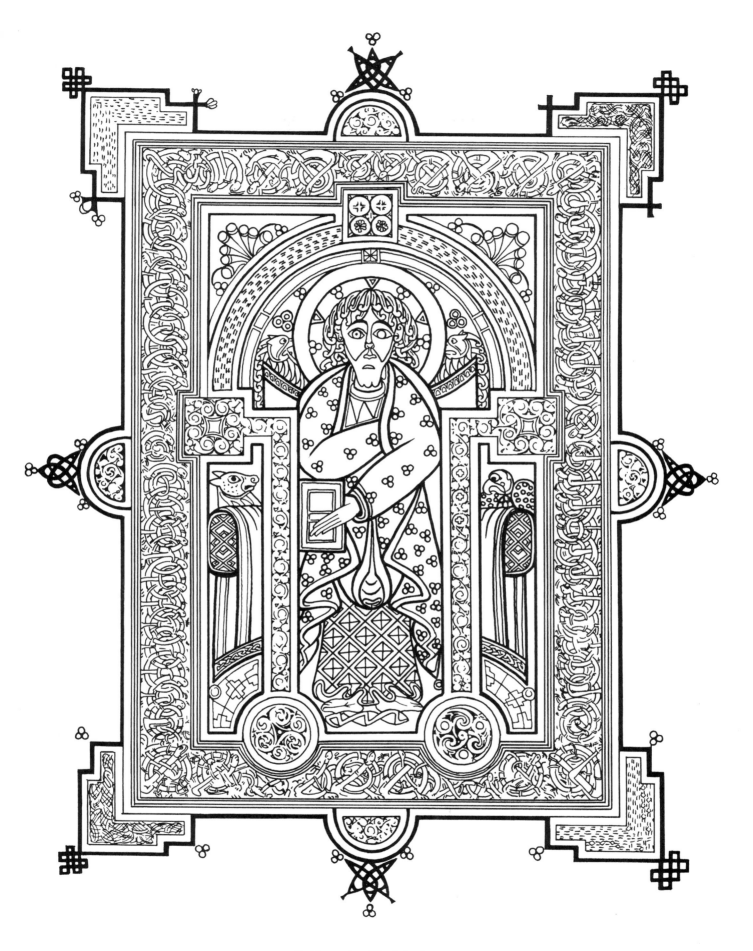

7. Portrait of St. Matthew.

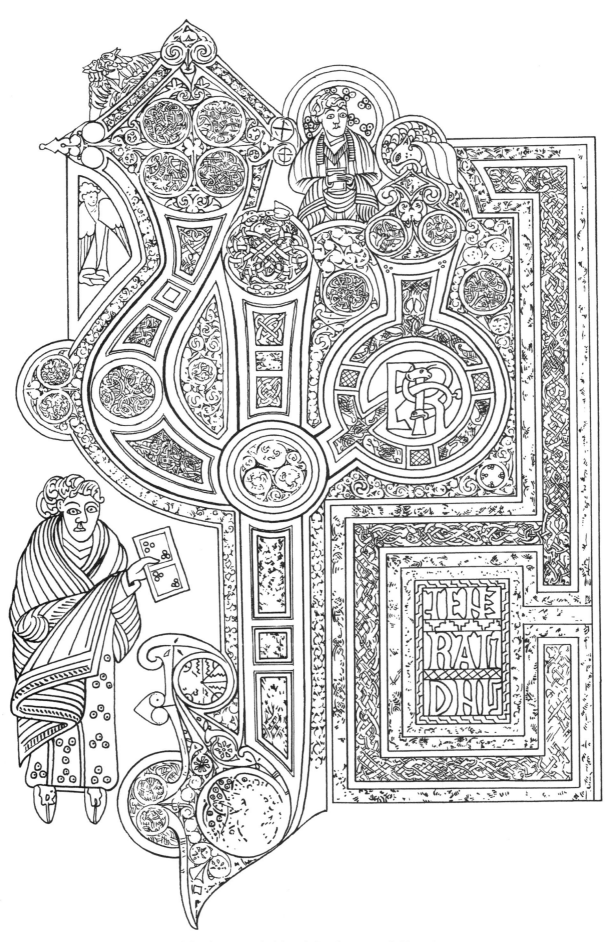

8. Matthew 1:1 (table of the descent of Christ).

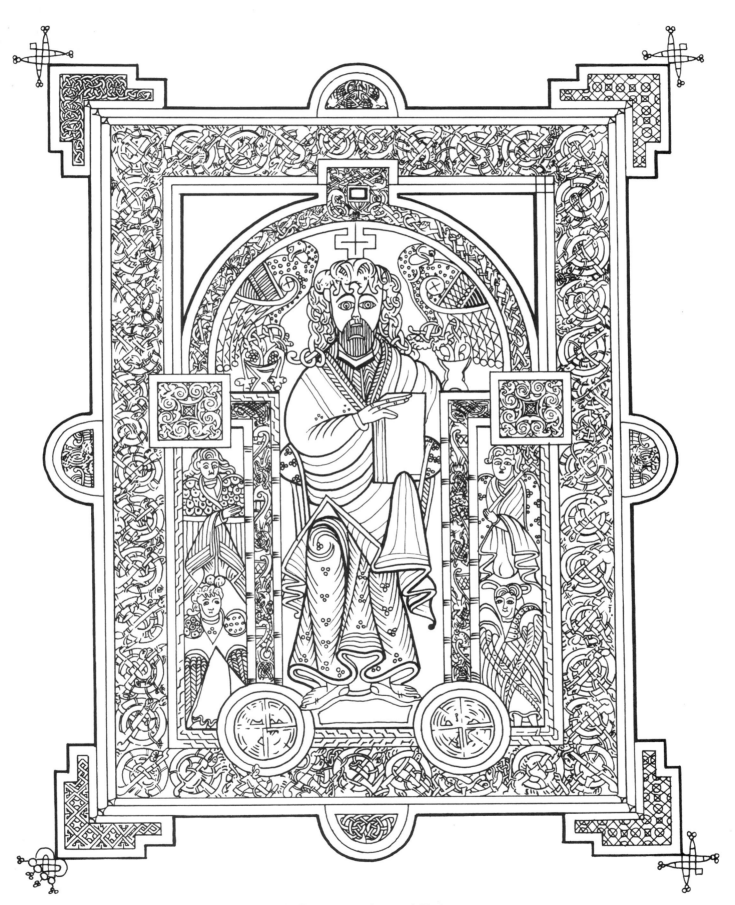

9. Portrait, perhaps of Christ.

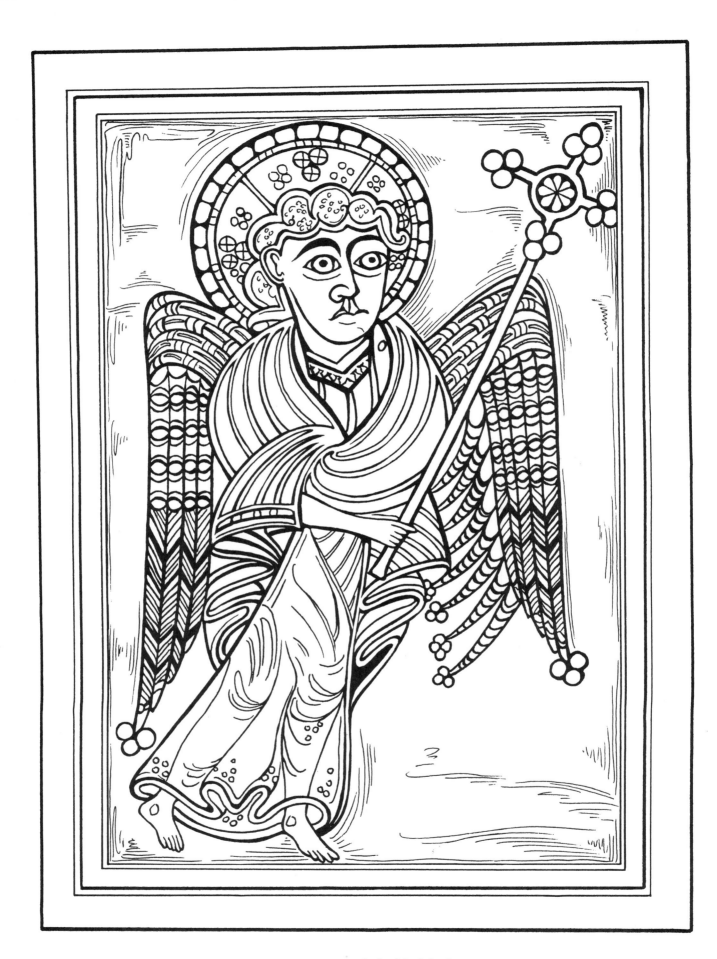

10. The Man, symbol of St. Matthew.

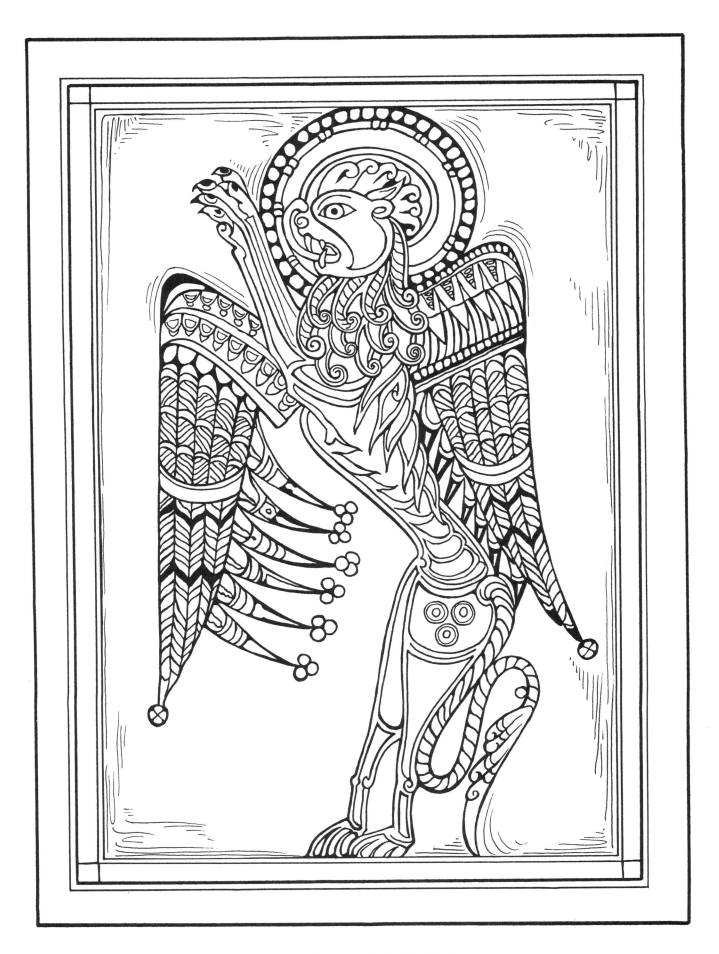

11. The Lion, symbol of St. Mark.

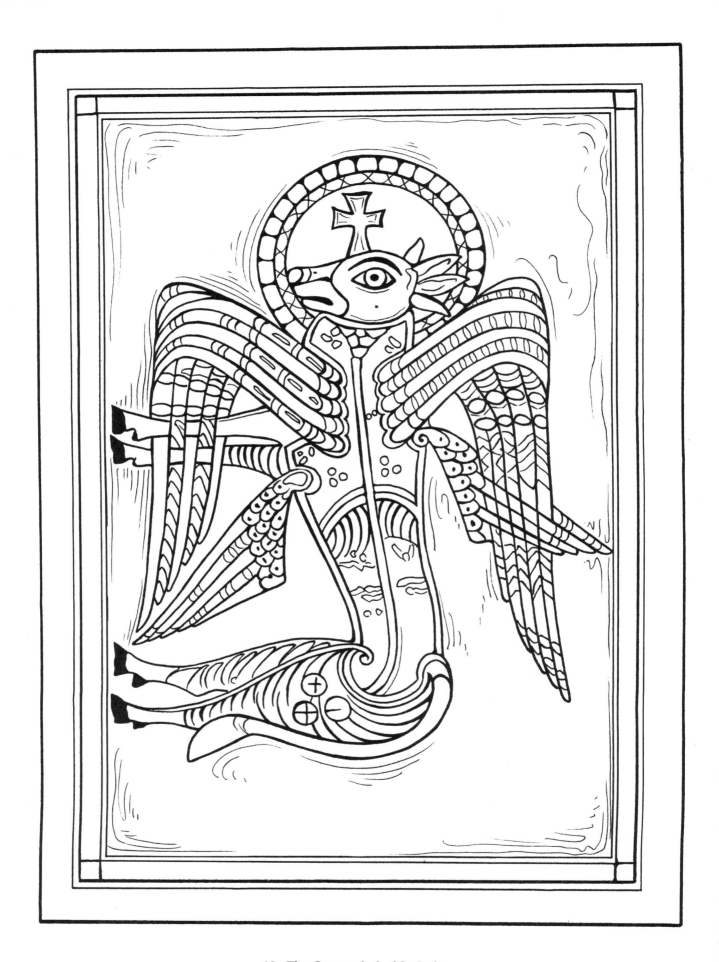

12. The Ox, symbol of St. Luke.

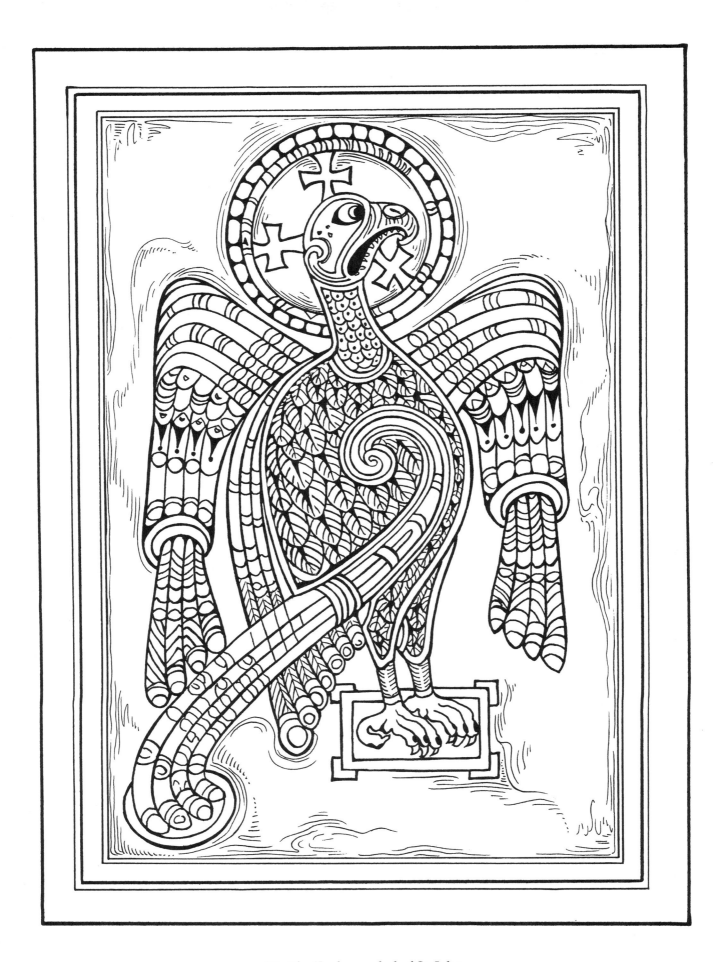

13. The Eagle, symbol of St. John.

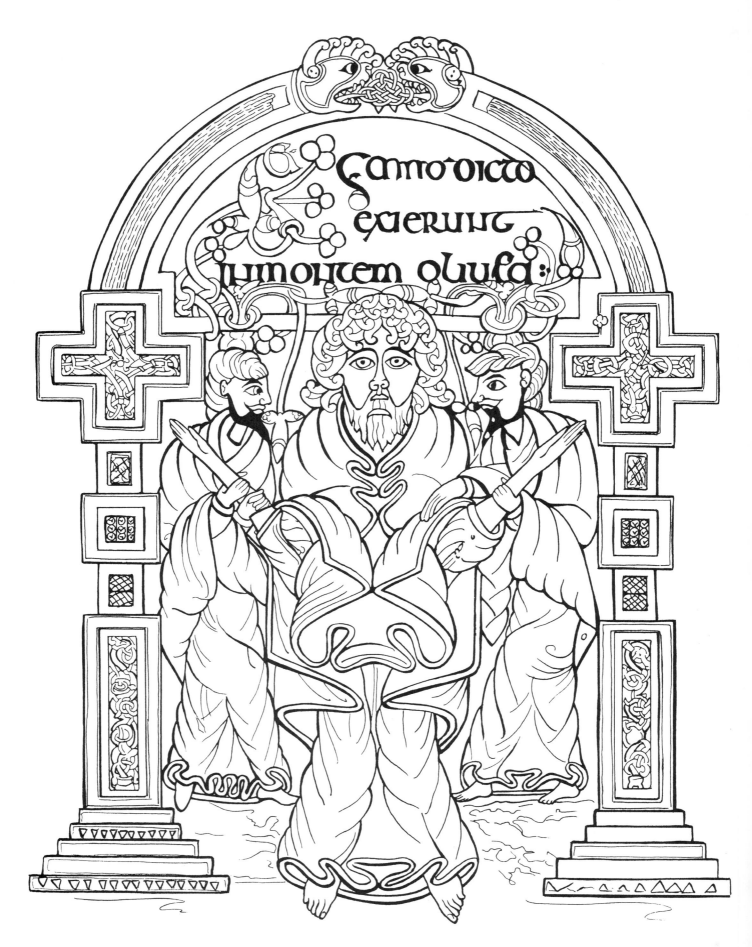

14. The Arrest of Christ, Matthew 26:30.

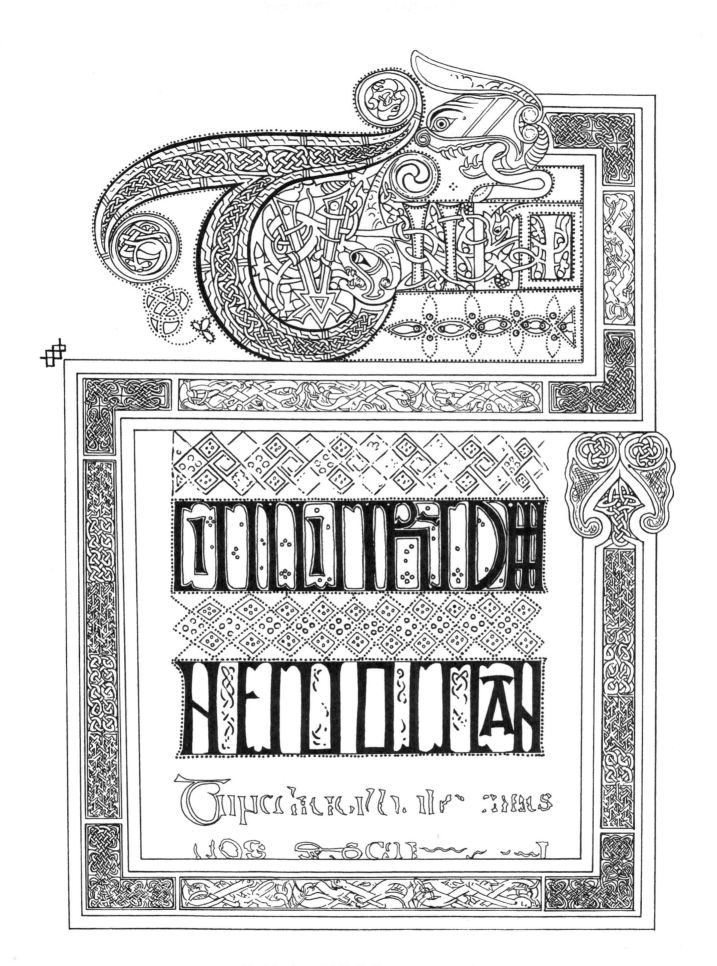

15. Matthew 26:31. Full-page ornament.

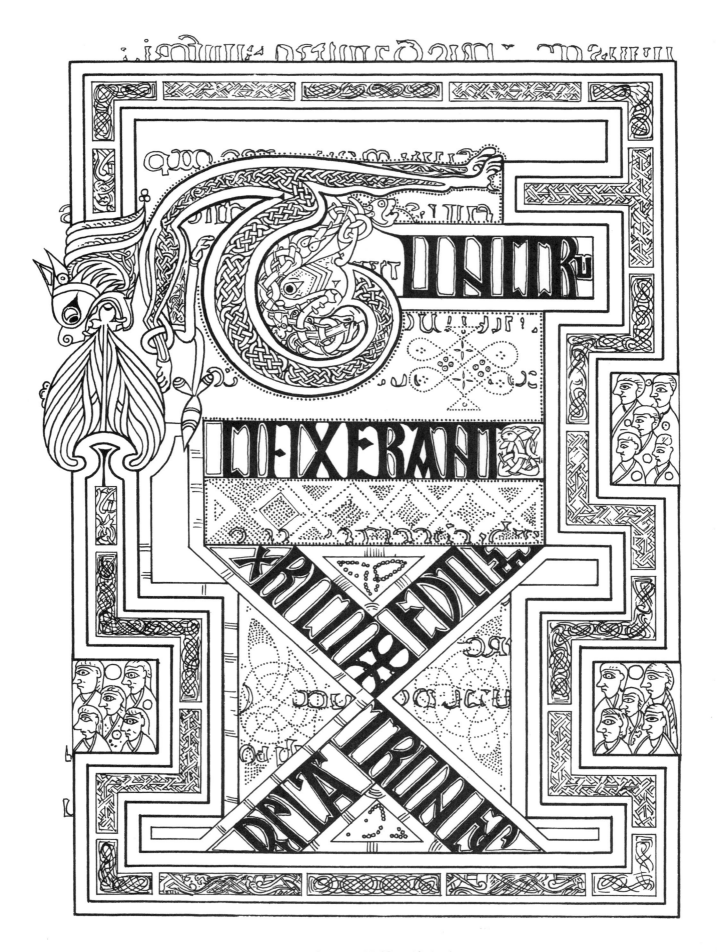

16. Matthew 27:38 (Crucifixion).

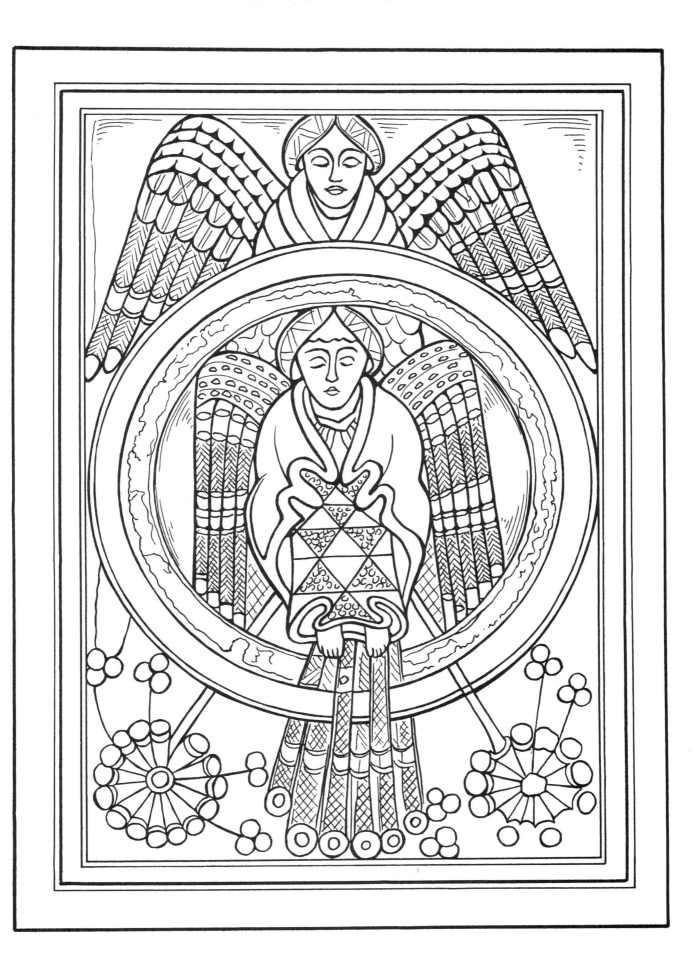

17. The Man, symbol of St. Matthew.

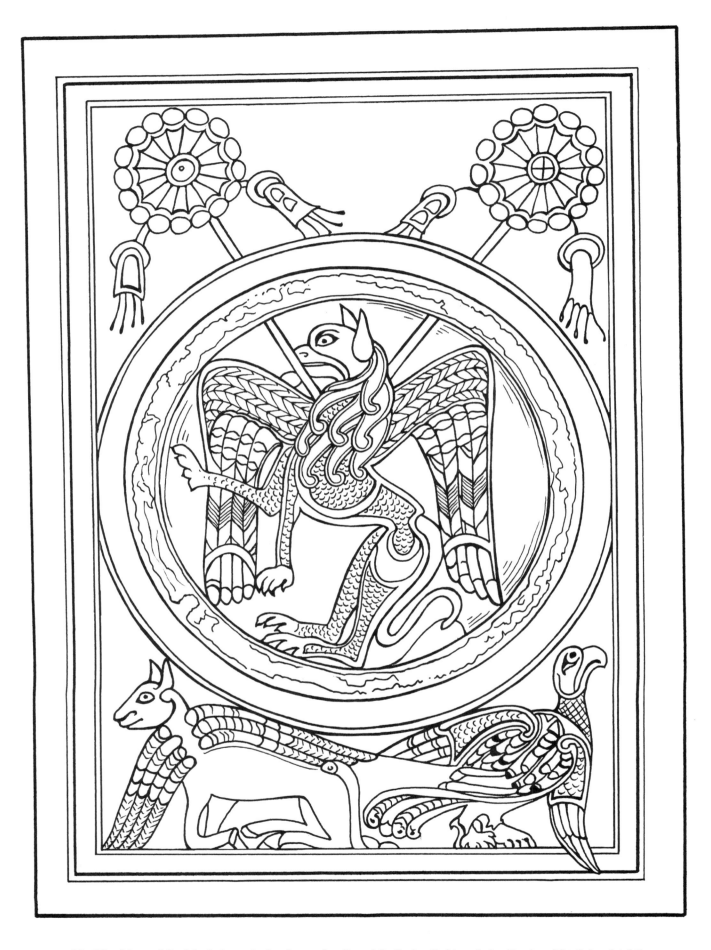

18. The Lion of St. Mark in a circle above the Ox of St. Luke *(left)* and the Eagle of St. John *(right)*.

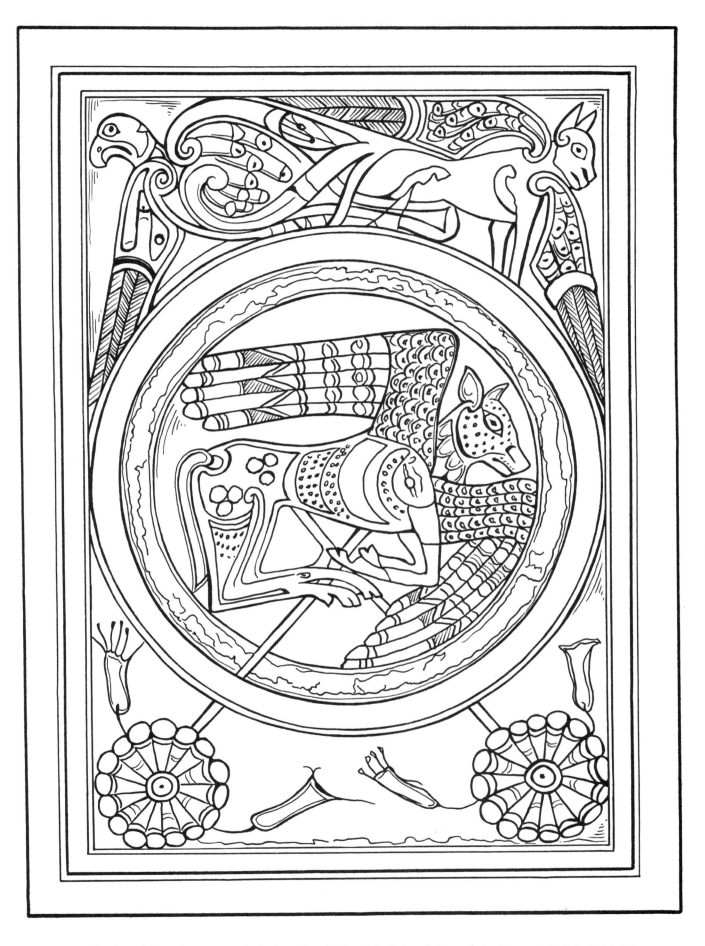

19. The Ox of St. Luke in a circle below the Eagle of St. John *(left)* and the Lion of St. Mark *(right)*.

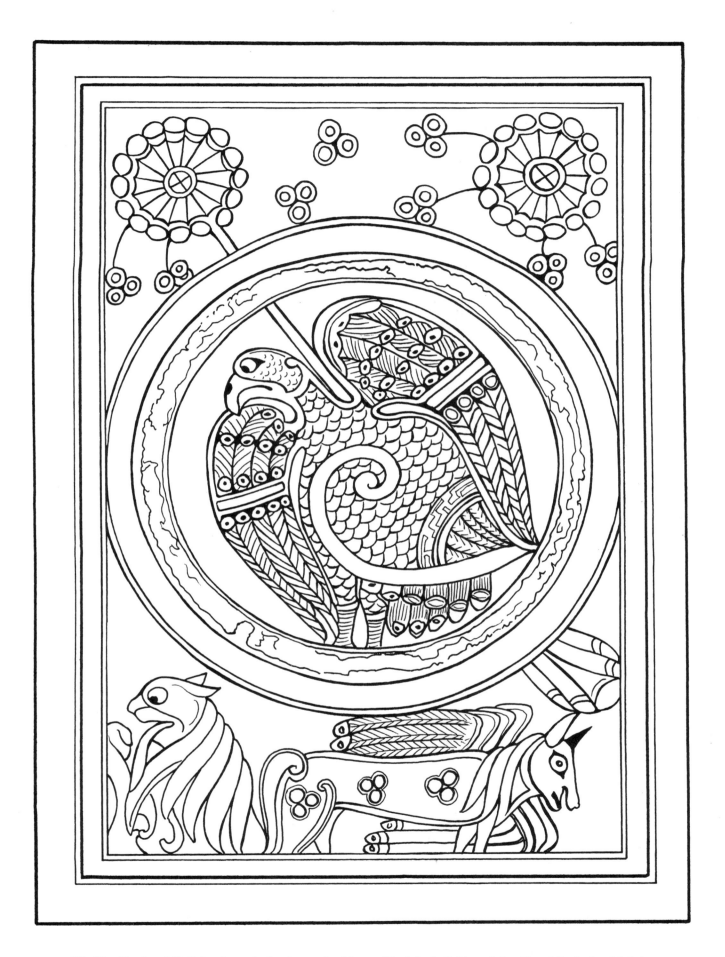

20. The Eagle of St. John in a circle above the Lion of St. Mark *(left)* and the Ox of St. Luke *(right)*.

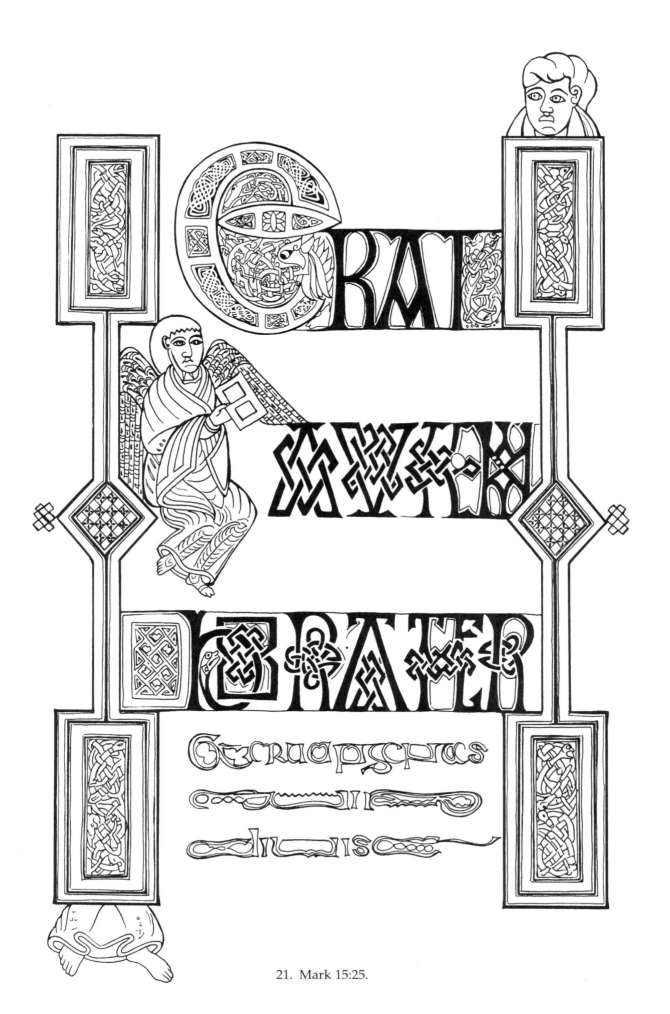

ERAT
AVTEM
ORA TERTIA

Gtcruapypcnas

edinnis

21. Mark 15:25.

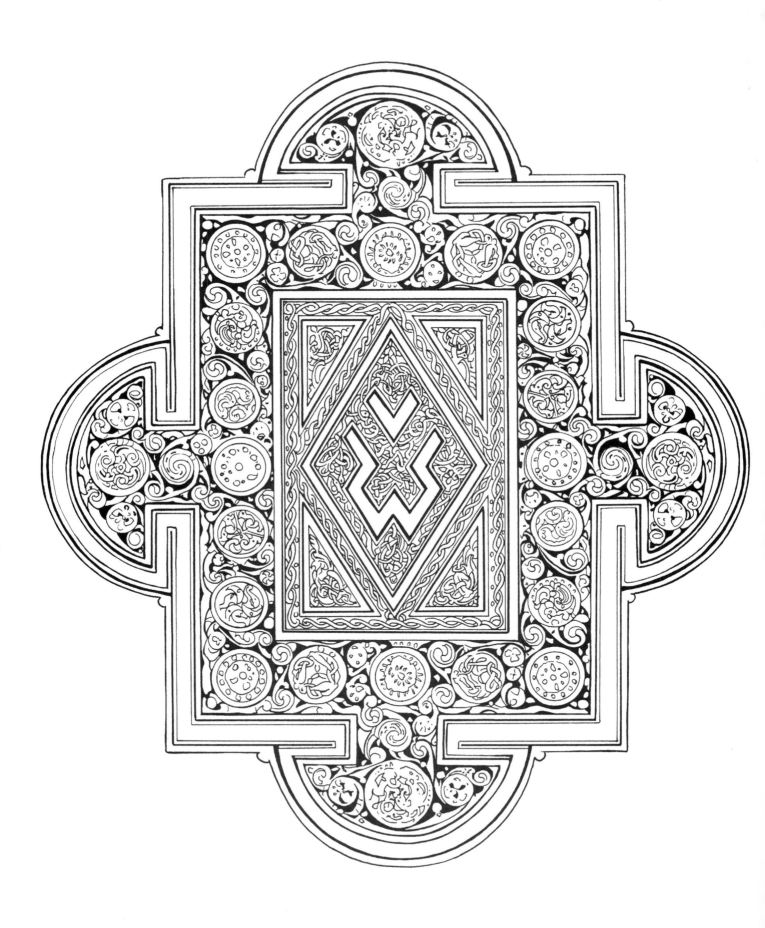

22. Beginning of the Gospel According to Luke (detail).

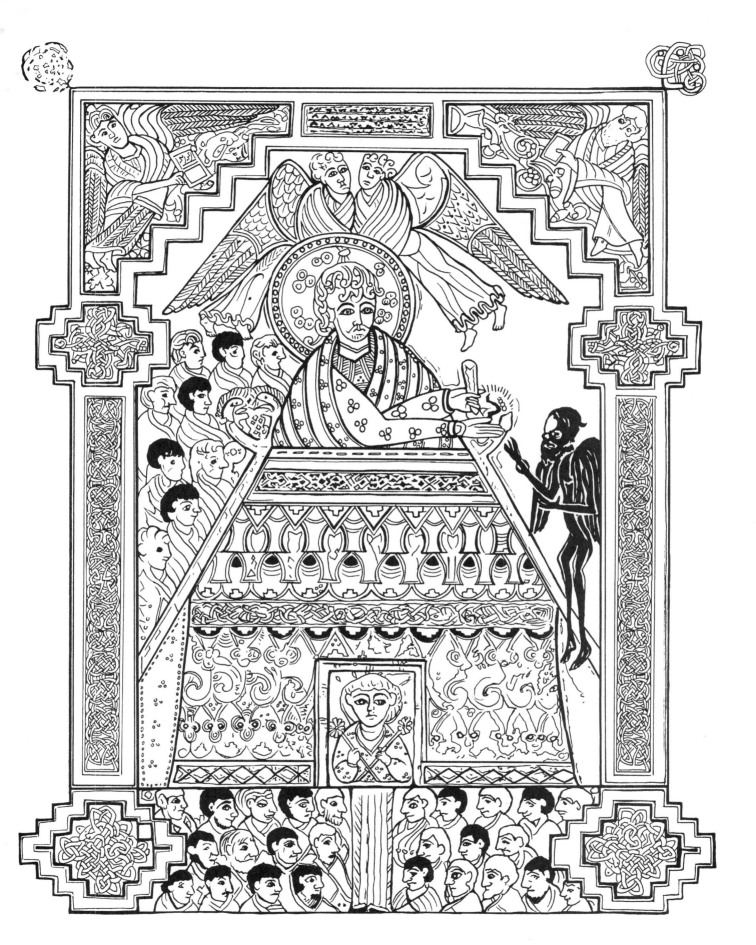

23. The Temptation.

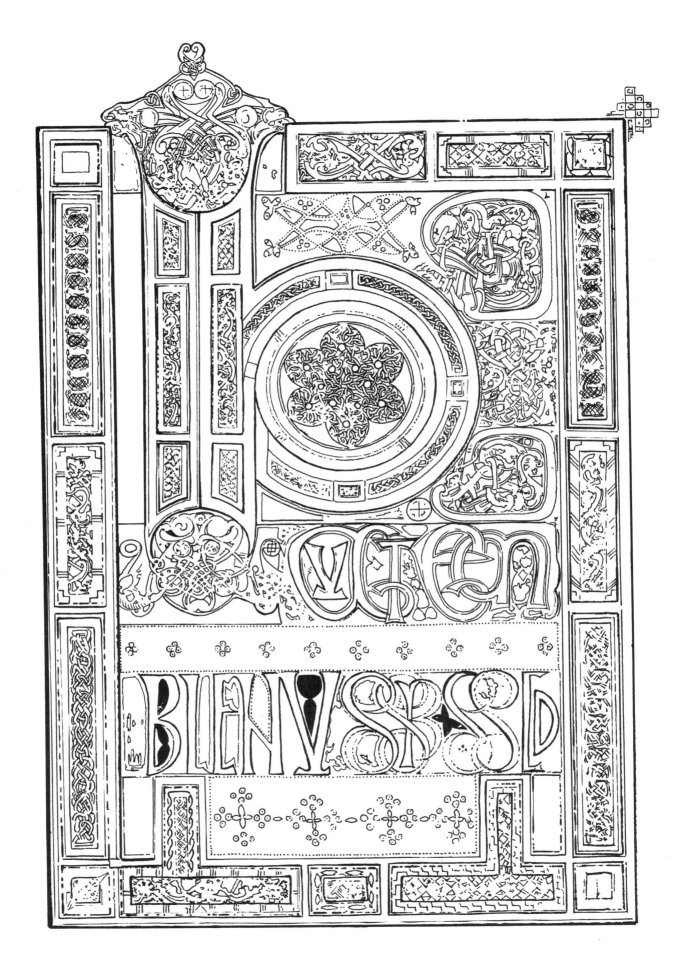

24. Luke 4:1. Full-page ornament.

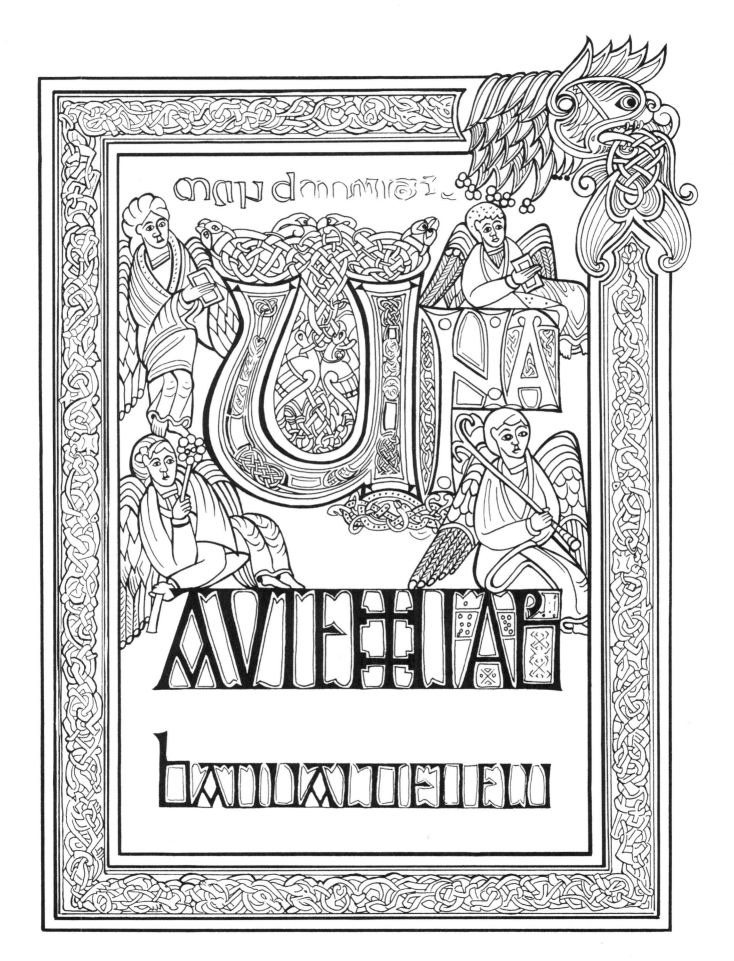

25. Luke 23:56 – 24:1. Full-page ornament.

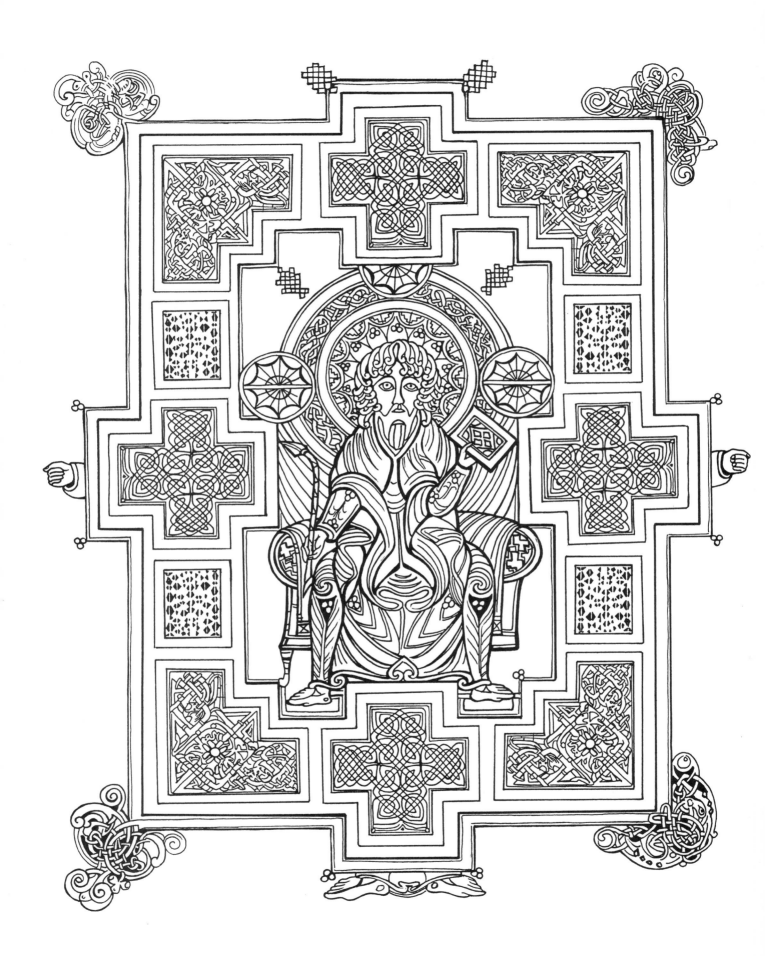

26. Portrait of St. John.

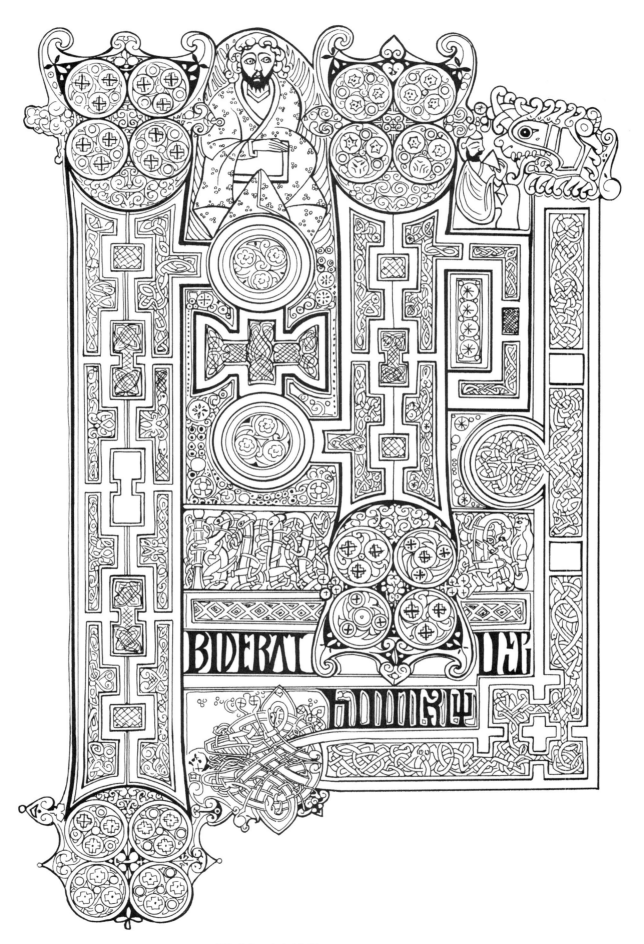

27. John 1:1. Full-page ornament.

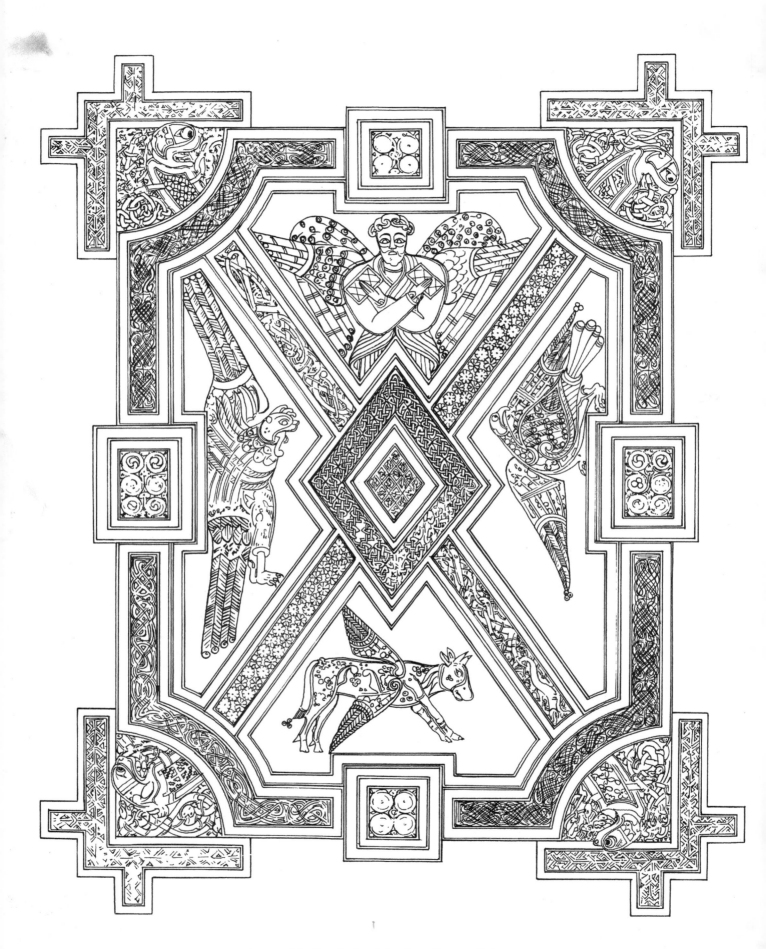

28. Symbols of the four Evangelists.